THE INDELIBLE SCAR
OF A LOST LUST

THE INDELIBLE SCAR OF A LOST LUST

CHRISTIAN C. EKWUNIFE

authorHOUSE®

AuthorHouse™
1663 Liberty Drive
Bloomington, IN 47403
www.authorhouse.com
Phone: 1-800-839-8640

Published by AuthorHouse 09/20/2012

ISBN: 978-1-4772-1733-7 (sc)
ISBN: 978-1-4772-1734-4 (e)

Library of Congress Control Number: 2012910223

This book is printed on acid-free paper.

DEDICATION

I wish to dedicate this book with deep appreciation to God and the following people who have had positive influences in my life, but have transcended into eternal glory:

.MY Mother-Father; Okpo Matagu,
.MY sisters: Gold Nwago Arinze[nee Ekwunife];and Grace Chinwe Eze[nee Ekwunife]

May your gentle souls continue to rest in peace.
—CCE

ACKNOWLEDGEMENTS

In the journey of life, one gets to meet with people. Many stand out to provide encouragement, education, motivation, and inspiration to achieve greater heights regardless of obstacles in the way. Others fall in this category of those who have graciously provided me with ample opportunities to acquire deeper knowledge, economic stability or pointed me in the right direction when at cross-roads. Some who have been of great significance in my life include:

My friends: James I. Eshiet, Professor Alex C. Asigbo, Prof. Tracy Utoh, Dr. M.M.Umukoro, Prof. Dapo Adelugba, Osagie D. Enabulele, Chief Olusoji Olaide Babalola, Pastor Grateful, Late Wellington Enabulele, CH [CPT.] Linda Murtala, DSG Fuentes, PVT Jenkins, Sgt Nicole Hart, Pauline Adekoya, PR1 Roach, 1st Sgt J. Olivera, LT. D. Kurber,1st Sgt Moore, Sgt C. Kennedy, SPC Ryan Fields, Ssg Harding, Sgt Brewer, Sgt Taylor, Ssg Navarro;

All my Platoon Colleagues and the entire 82nd Airborne
Division of the US Army.
My bosses at the City of Oakland, California Office of
Parks and Recreation- Director. Audree V. Jones-Taylor,
Supervisor Karis Griffin, Ms. Tomye Neal-Madison, and
Center Director Chief Kola Thomas;
My good friend Elizabeth Toluwalase Babalola.

I am eternally grateful to you all.

CHARACTERS

UKANDU - Osondu's father

ULOOMA - Osondu's mother

OBIAGELI - A belle in Umuagwu

OSONDU - Obiageli's fiancé ·

IFEOMA
CHIOMA]-Obiageli's friends

UWAKWE - A Dibia

OKOLO - The Drunk

TOWNS PEOPLE/ELDERS

DRAUGHT PLAYERS

AN ETHEREAL FIGURE

BY CHRISTIAN C. EKWUNIFE

PROLOGUE

Dim lights reveal two figures lying each on a bed opposite each other. The lounge and the adjoining bedroom show signs of affluence. The wall clock reads a quarter to five in the morning.

An ethereal figure, all wrapped in white linen, appears pacing round the parlour as it addresses one of the figures on the bed who stirs intermittently on his bed. A flute playing unpunctuated, but rhythmic dirge is heard from the background.

ETHEREAL FIGURE

The day you set your feet in Umuagwu, you will surely die! Beware! [*The first figure wakes up shaking visibly*]

FIRST FIGURE

Who are you? Show your face! I rebuke you in the name . . . [*Changes his mind, stalks to the second figure still sleeping, stares at it briefly still panting*]. Mama! Mama!! [*The flute stops as*

the second figure wakes up with a start]. Mama, tell me, who is Umuagwu?

SECOND FIGURE
[*Sleepily*] What do you mean?

FIRST FIGURE
I mean what, or who is Umuagwu?

SECOND FIGURE
[*Fully awake*] A-ah? You sound strange. Were you dreaming, or what is the matter with you?

FIRST FIGURE
It was more of a vision than a dream, mama. I was wide awake, and voices, flute, all so eerie that . . .

SECOND FIGURE
[*Interrupting*] In that case, it was a nightmare. Let's talk about it in the morning when the dark blanket of the night is fully folded.

[*No sooner they retire, than the flute resumes, then voices begin chanting with a heightened dread*]

VOICES

Beware of Ukandu

Beware of Umuagwu

Cut the tree, leave the root

The root will surely spring to life.

[*As the chant increases in rhythmic velocity, the first figure keeps turning and rolling on his bed. Then, a sharp halt.*]

FIRST FIGURE

[*Screams*] No.o.o.o.o.o.o. [*Jumps out of bed at the same time with second figure, standing face to face and staring at each other questioningly*] BLACK OUT.

MOVEMENT ONE

SITUATION 1

A lady not less than twenty-seven years is seen feeding a baby from a bowl of pap. The baby begins to cry.

ULOOMA

[*To the baby*] Shoyi! Shoyi!! Don't kiai, ish nosh my falsh. Ya fadya shesh I should not gish you mai biesh. He shesh mai biesh milk ish nosh goosh for you. Shoyi!! You heah? [*Raises a lullaby*]. [*Ukandu enters with a gun and other hunting paraphernalia*].

ULOOMA

[*Perfunctorily*] Welcome Nnanyi.

UKANDU

[*Nonchalantly*] Thank you.

ULOOMA

You look distraught. How was the bush today?

UKANDU
You still ask? Didn't you see the elephant I just brought in here? [*Hisses*]

ULOOMA
But it is not as if that was a question no one ever asked.

UKANDU
Go ahead, enh? Ask ten, twenty and a thousand of such silly questions and expect me to answer them. You see a maggot-infested carcass of a goat lying by the way side, and you ask [*mimicking*] "Is this goat dead"?

ULOOMA
Whatever it is that has upset you, God knows I did not drive the animals away from the noose of your traps; neither did I scare them away from the aim of your rickety gun.

UKANDU
[*Threateningly*] Woman, mind your wagging tongue else you'll get it twisted within that smelly groove of yours.

ULOOMA
Look Nnanyi, you still haven't pointed out my fault, or the source of your unhappiness. This is not the first time you

would be returning empty-handed from the bush. So, what is this fuss about?

UKANDU

A laughing sculpture does not voice its displeasure.

ULOOMA

What does that mean?

UKANDU

A house that mischievously harbours smelly rats stands the risk of being despised.

ULOOMA

[*Running out of patience*] When you finish with your senseless ranting, your break fast is on the table. [*Picks the baby and stalks towards the inner room*].

UKANDU

[*Thunderously*] Stay where you are, you insolent bitch! [*Ulooma swings round as if propelled*].

ULOOMA

What else do you want from me owner of the world?

UKANDU

Happiness! Ulooma, happiness. Every woman is the source of a man's happiness, not woe, yet, you, since I . . .

ULOOMA

[*Cuts in*] Your life accounts for what you are, yet you seek to reach the sky.

UKANDU

What was that? [*Silence*] I said what was that?

ULOOMA

I thought you wanted to talk. The mouth is just a house of words, so, go ahead and mould your own.

UKANDU

Talk? [*Spits despicably*] what man has time for such frivolities.

ULOOMA

Then what else do you desire from me? Is it love? That, you've got without a grudge, or have you ever knocked without response?

UKANDU

[*Snappily*] That is far beyond the point. It's joy! [*Getting emotional*] Happiness, Ulooma, peace of mind is all I need.

ULOOMA

[*Perplexed*] But how do I owe you those things you have just mentioned?

UKANDU

When a finger is hurt, do others plead innocence in the face of pain?

ULOOMA

[*Exasperated*] Look Ukandu, permit me to call you as I've never done. Some truth, no matter how bitter they are, must as a matter of necessity be told. The peace you need cannot be found unless you change your ways of life.

UKANDU

[*Stupefied, looks at her with an open-mouthed bewilderment as she stalks into the bedroom. Then, almost inaudibly he mutters "You are mad!"*]. BLACK OUT

SITUATION 2

A SHRINE. Some heathen wares are arranged in a haphazard way. Tied to the entrance are pieces of black, red and white cloth. Prominent among the wares is a big white basin. An elderly man appears from the shrine looking dreadful. He mouths some incantations, breaking kola-nuts and throwing the pieces in different directions.

<div align="center">UWAKWE</div>

Okokobioko! When the throat is dry, the thirst of palm-wine becomes valuable. It is not for nothing that Mother Nature denies wild beasts horns. Yet those with horns take to eating cud. Ukandu is too soft for that woman [*spits in defiance*] Tufiakwa! It is only with the toothless that palm-kernel boasts. [*Shrugs*] Well, if he wants to be rich, it's up to him to decide. After all, I did not invite him here. Our services, of course, are for the feeble-minded ones like him. The wise ones do not need us, and so whoever comes to us does so at his own risk. [*Sips from the gourd in his hand and spouts in different directions. As he turns to enter the shrine, Ukandu enters*].

UKANDU

The greatest Dibia of Umuagwu! One who communes and dines with our ancestors and gods alike. He whose status the foreign religions uphold in awe. Before you, I am, but a grain of sand. Therefore, I throw my body at your feet in greetings [*prostrates*].

UWAKWE

That is the spirit my son. The walking stick must not be taller than its holder. Sit up and let us go straight into the business of the day. But, why did you keep so long; and where are the objects of sacrifice??

UKANDU

[*Stuttering*] The mother . . . ehn . . . My wife . . .

UWAKWE

[*Threateningly*] Searching for suitable words to convey your lies?

UKANDU

[*Defencelessly*] No . . . but . . .

UWAKWE

Ukandu! Ukandu!! Ukandu!!! How many times have I called you?

[*Almost inaudibly*] Three times!

UWAKWE

Do I need to remind you in whose presence you are? [*Picks up a two-pronged metal gong and plays a short pacifying tune with it*]. Let it be known to you that Eke, the python of wealth has been keeping his mouth wide open since the first cock-crow to receive its pay. To close that mouth now needs another sacrifice-a live goat! But, you may pay in cash.

UKANDU

I will bring the money before noon.

UWAKWE

Let me warn you that though Mmuoego is benevolent, he can be extremely vicious when deceived twice. Therefore, you must, at the first cockcrow tomorrow morning be here with the complete objects of sacrifice. Understand?

UKANDU

Yes Nnanyi! But . . . ehm . . . please Nnanyi . . . ehm . . .

UWAKWE

[*Snappishly*] What?

UKANDU

The fee, Nnanyi!

UWAKWE

Oh, that? [*Taps on the gong a couple of times and looks into the white basin with exaggeration for an imaginary response*] Mmuoego says, everything, including the expiatory charges of today's offence is twenty-two thousand naira only.

UKANDU

Thank you N'nanyi [*Prostrates*].
LIGHTS

SITUATION 3

Ukandu, back at home, mulls over the possibility of convincing the wife on his plight.

UKANDU

[*Soliloquising*] To drag the horse to the stream is one thing, to force it to drink from the stream is yet another. Agreeing to Uwakwe's terms is never a problem, but . . . [*Stops as he hears a sound from within the house. Tip toes to confirm whether someone is around. Calls, "Ulooma! Ulooma!! No response comes out, he hisses*]; these rats can scare one to death. [*Continues*]: how on earth can I talk this woman into seeing reason with me? [*Ulooma eavesdrops*]. There is no need to tell her. She won't agree to it. Our people say that the owner of one thing is like one who doesn't have. Should I dialogue with her on this? No, I'm sure she won't ever consent to it. Not after those seven long years of marriage without a child. But what should I do? By the first crow of the cock tomorrow morning, Uwakwe's python would have opened its mouth in readiness to swallow our child [*Ulooma, eyes wide open, cups her mouth with her hands*] so that I may become rich! Rich!! Extremely rich!!! Yes, rich! Mansions! Flashy cars! Money! Money! Respect! Power! Influence! Money! Money! Women! Women! Money!

Money! Money! [*Getting wild with excitement, he breaks into a song and dances round briefly*].

SONG:-

Ego nabia[*2ce*]	Money is arriving[*2ce*]
Ego bu ugwuu	Money is respect
Ego bu ife nine	Money is everything

[*Snapping out of the reverie*]. But, what man counts his chickens before they are hatched? [*Pause*] Look, Ukandu, be a man, think positively, don't give frailty a chance. [*With renewed enthusiasm*]. Wife or no wife, I have made up my mind. Tonight, I must secretly leave home with the child. Ulooma must not know.

ULOOMA
[*As Ukandu goes out*] Onyeoshi-Iberibe! Ekwensu kpo gi oku! Anumanu!!
BLACK OUT

SITUATION 4

Night. Ulooma is seen putting finishing touches to her packing into a trunk box.

ULOOMA

Ah my God, just like I have often feared, Ukandu is just one of them! One of those wicked lots in this useless village! What a life! What is mankind turning into? Ehn? A monstrous vampire of a husband! Viper toothed in-laws! Man-eating witches and wizards as parents! My God how can I find solace in this jungle? To whom do I turn? Every eye in this village is red with evil intent, every heart is black with bleak thoughts and every smile is disgusting with dreadful pincers ready to grab and devour. I hate this land! I hate Umuagwu!! I've got to flee; but it's already too late. [*Ponders briefly*] what shall I do now? [*Pauses; then tries to make up her mind on something. She nods, as the idea becomes more and more convincing to her*]. Throughout the night I dare not blink; my eyes shall be on my child all through the night. And tomorrow morning before daylight kisses the ground, my child and I will be on our way out of Umuagwu for good. [*Soliloquising*] Tufiakwa! Uwa di egwu! What a beast Ukandu is! Chineke me.e.e.e! if this were a dream I would have blamed my "chi" for it [*mimicking*] "Don't ever touch his mouth with breast". I should have known, it was just to deprive me of my only pride. [*To the baby*], your papa is such a vicious and senseless beast. He wants your life in exchange for wealth. You are my only hope and life. I will fight to preserve your life with the last of my breath. And when you grow up, you will this song for me.

SONG: Nne mu zorumu

Ewoo

Nne mu oma Chineke biko gozie gi

Ewoo . . . [*Sings as she lulls the baby*].

[*Ukandu comes in, a bit tipsy*].

ULOOMA

[*Aside*] He will have to kill me first before devouring my child.

UKANDU

A-ah, Ulooma, so you people are still awake?

ULOOMA

[*With feigned innocence*]. The baby is just trying to catch some sleep after having woken up with a scream from what seems to me a horrible nightmare.

UKANDU

Nightmare?

ULOOMA

I don't know, I just guessed. [*Tries to change the subject*]. I thought you went to the bush.

UKANDU

No. But you know I wouldn't have gone without my gun. [*Tries to change the topic*]. Is he still awake?

ULOOMA

Almost asleep. But Ukandu, tonight's weather is much more alluring for the animals willing to mate. You would have had many games tonight. Why don't you just try going . . .

UKANDU

What do you know about weather and the art of hunting?

ULOOMA

My father used to be the best hunter in Umuagwu who . . .

UKANDU

Go to sleep and stop telling me unnecessary stories about your late father's hunting expeditions.

ULOOMA

Nnanyi, you have been drinking again.

UKANDU

[*Stretching on the bed*]. Please, leave me alone. Won't you sleep?

20

ULOOMA

You need the sleep more than I do.

UKANDU

Alright, goodnight.

ULOOMA

This is strange! This is your very first time of bidding me good night since we got married seven years ago.

UKANDU

Oh God! Look, woman, I need this sleep badly.

ULOOMA

[*Sarcastically*]. Are you sure? Meanwhile, how about the rat poison you said you would buy? [*No response*]. Ukandu! Ukandu!! [*No response*]. She turns down the flame of the lamp and retires to her bed with the baby. Ukandu stretches his hands and picks the baby; then tiptoes out. Ulooma, who has been watching with acute fear, gets up and tiptoes after him almost immediately. Almost immediately, dimmed lights catch up with Ukandu meandering his way through the shrubs on a bush-path, with the child on his left shoulder.

A voice from the bush calls out shrilly "U-k-a-n-d-u!"

Ukandu stops dead, and swings round to behold a figure not quite defined, a couple of yards away from him.

FIGURE

"Ukandu, the cry of the innocent child moves me.
Chiumuaka, God of children, and I the
Queen of the night have seen you.
The life you're about to waste is precious
The blood you're about to spill is innocent.
Therefore, we earnestly advise you in your
Interest, to drop the child and spare your
Life. Drop the child and spare your life.
D-R-O-P T-H-E C-H-I-LD A-N-D S-P-A-R-E
Y-O-U-R L-I-F-E."

Ukandu, as if remote-controlled by awe, slowly drops the child and takes to his heels. The figure, in excitement, moves towards the child and uncovers her wrapper to reveal an overjoyed Ulooma.

"It worked! My God, it worked!! [*Picks the child*].

My dear baby, from here, we move on to the land of bliss, where we'll be known by none; and strangers shall be our friends. This is a race of life from death.

Henceforth, your name shall be Osondu, meaning the race of life."

[*She raises a song and begins her journey as there is a slow fade out while she dances out*].
LIGHTS.

SITUATION 5

Morning: A completely down-cast/dejected Ukandu sits in front of the shrine as Uwakwe mutters some incantations round him with a white bowl in the left hand from which, with the help of a broom, he sprinkles some liquid on Ukandu.

<center>UWAKWE</center>

[*Hysterically*]. She ran away with the major sacrificial item of Mmuoego.! [*Laughs shrilly*]. When shall the fools know that every bird that flies in the sky has its legs pointed to the ground? When the day is old enough, the hen returns to

roost. Home coming sometimes may be with joy. Sometimes it may sadly leave some tears behind. Ukandu, you allowed your wife to deceive you! You allowed her to fool you! I saw everything.

UKANDU

[*Desperately*]. Is there a way out to get my wealth, or has all my future come to naught?

UWAKWE

When a ram needed for an urgent sacrifice suddenly develops mysterious spots on its body, a giant goat can be substituted.

UKANDU

[*Confused*]. I don't understand. You mean I should bring a goat?

UWAKWE

Who is talking about goats?

UKANDU

I thought you said a goat could be substituted.

UWAKWE

O-0h! I see. You still do not know the status of Mmuoego. I mean a giant goat!

UKANDU

[*Aside*] Giant goat! Giant goat!! Giant goat!!!

UWAKWE

You do not seem to need the wealth. But note no one sends Mmuego on a fruitless errand. Therefore, what you started on your own free will, must be completed.

UKANDU

But I am not unwilling. I am still waiting for your further directives. So long as riches shall be my portion, I am ready to do anything, just anything you wish.

UWAKWE

Not what I wish, but what Mmuoego desires.

UKANDU

[*Desperately*]. I have said, name the price. A thousand Ulooma may flee my home with a thousand babies. But my wish to be rich remains constant.

UWAKWE

[*Raises a song as he fumbles with his divination paraphernalia, settles down for consultation*]. When foolishness in the head leads the butterfly into the web of a spider, the whole body of the butterfly suffers in agony. We do not invite people. People bring themselves to us, and we make them happy. But happiness is made of three colours, the white, the red and the black. Ukandu, make your choice, but be cautious.

UKANDU

[*Aside*]. White, to me, signifies tastelessness, powerlessness, and nothingness. Black portends doom-Tufiakwa! Red is bright and alluring [*To Uwakwe*] It is red I choose. [*Uwakwe unties the red piece of cloth from the entrance of the shrine, spreads on the floor, places some cowries shells on it, mouths incantations, dips it into the water in the white basin, fixes his gaze into the basin*].

UKANDU

My mind is made up.

UWAKWE

You have to surrender your manhood!

UKANDU

W-h-a-t?

BLACKOUT.

SITUATION 6

Enter two girls of about twenty-five years each. They are obviously returning from the stream with each carrying her load.

CHIOMA

[*Giving Ifeoma a nudge*]. A young python that attempts to swallow a cow must shed tears before he gives up.

IFEOMA

[*Surprised*]. Why? Chi-Chi, I always tell you that your tongue is too large for your age. How can you speak like old women or old men relishing palm-wine in the bar.

CHIOMA

It's true, you see, any child that tries to run before he learns how to walk will surely invite bruises to his tender skin.

IFEOMA

[*Provoked*]. Look, if you know you're not going to make sense, stop chattering like a parrot.

CHIOMA

You see, the trouble with you is that you always think you like her more than I do.

IFEOMA

[*Interrupting*]. Who?

CHIOMA

Who else, but our friend.

IFEOMA

Obiageli?

CHIOMA

[*Emphatically*]. Yes!

IFEOMA

So what about her? Enh? What is turning your gall against her? You have been sounding jealous of late.

CHIOMA

[*Derisively*]. Jealous? Tufiakwa! Instead of that, let me die a celibate.

IFEOMA

[*Matter-of-factly*]. Look, I have told you before, I don't like gossiping. And you should have known that by now.

CHIOMA

A foolish fowl that turns her behind against the wind will have herself to blame.

IFEOMA

There you go again! Speaking in tongues!

CHIOMA

I am not speaking in tongues. I'm only saying the truth.

IFEOMA

And what truth if I may ask?

CHIOMA

The truth that your friend . . . Our friend has made the greatest mistake of her life. Or, have you not heard of her misfortunes?

IFEOMA

[*Picking interest*]. Misfortunes? God forbid! Misfortunes! What kind of misfortunes?

CHIOMA

Ukandu, she complained, does not knock at her gate, neither does he till the ground.

IFEOMA

Oh my goodness! What do you mean?

CHIOMA

[*Mischievously*]. Please, don't tell anybody I told you . . . o

IFEOMA

[*Worried*]. What are you talking about . . . I mean . . . you confuse me.

CHIOMA

[*Resignedly*]. Well, I see you are still a kid to whom proverbs have to be explained, after they are spoken. What I mean is that Obiageli, our friend, has not known the joy of womanhood since her marriage to Ukandu. In short, Ukandu is not a man.

IFEOMA

Chineke . . . mee . . . ee . . . !! [*pause*] please Chioma, tell me
you are joking.

CHIOMA

[*Nonchalantly*] I'm surprised she hasn't told you.

IFEOMA

Perhaps that was why she sent for me yesterday.

CHIOMA

Well then, let's see her this evening, say, before the fowls and
birds retire to the roosts. Then, the husband shall have left
for hunting.

IFEOMA

All right then, I'll wait for you under the great "udala" tree.

CHIOMA

Good. Till then, bye.

IFEOMA

Bye.
EXEUNT [*LIGHTS*].

SITUATION 7

A young lady, Obiageli is sitting on a pouf in a considerably well furnished living room. Her sad mood is in sharp contrast with the elegance of the room and tension piles up as she looks up intermittently with the same sadness. As she raises a song moodily, tears form a rivulet down her cheeks.

SONG: Uwa ozuru onye?

Uwa adighi onye ozuoru

Uwa adighi onye ozuoru ma'ncha.

OBIAGELI

[*Still sobbing*]. Indeed, it is a hard life for a girl of my age. What is wealth compared to happiness? Can money give the joy a child can? At nights, instead of being a husband I thought I married, Ukandu becomes a brother who abhors incest. The rope that makes him a man becomes as useless as a filthy rag. Ever since I married him, I've never felt the joy of womanhood. My daily yearnings fall on deaf ears. At least what makes a woman beat her chest in the presence of neighbours is the manliness of the man she has at home. But this one is just a useless rotten cocoyam leaf. For seven months now, seven good months, since I married this . . .

this . . . I don't even know what to call him, I have been treated like yet another man in this house. I mean, even if I were a man, after all I hear some men do . . . [*checks herself, then changes her mind; getting a bit emotional*] for how long, I mean, for how long shall this continue? [*Pauses, then resolutely*]. Tonight, I mean this very night, if Ukandu refuses to be the man everyone in Umuagwu assumes he is, I will sit him down and tell him my plight; for it is only a slave who sees the truth and ties his tongue in silence. [*A knock on the door, she quickly checks herself, rushes to the door, putting on a deceptive look. As she opens the door, Chioma and Ifeoma enter with an air of gaiety*].

OBIAGELI

[*To Ifeoma*]. I met your younger sister on my way from the market yesterday . . .

IFEOMA

[*Interrupting*]. Yes, she said you asked me to see you today unfailingly.

CHIOMA

I have been trying to let Ifeoma know about your trauma, but she is too daft to understand. [*Giggles*].

IFEOMA

[*Resignedly jovial*]. How do I blame you! Cheeky little brat!

OBIAGELI

I wonder why both of you always want to tear each other into pieces.

IFEOMA

The trouble is that Chioma's brain is too large to be caged in that small coconut of a head that she has.

CHIOMA

This is not the time to engage in frivolous talks, else I would have answered you. Therefore, silence remains the best answer for a fool.

IFEOMA

So what are you implying?

OBIAGELI

I hope you two did not come here to aggravate my emotional stress. What's the matter?

IFEOMA

Chioma always complicates issues. She talks and behaves like the witch she is.

OBIAGELI

Ify, watch your words!

CHIOMA

Let her alone. The termite that sees a piece of rock and mistakes it for a log of wood, lives to tell a tale of woe.

OBIAGELI

All right! Talk-talk-talk-cha-cha-cha-cha-cha-Aha! You both should have been co-wives married to Ukandu.

CHIOMA

What? "Tufiakwa"!

IFEOMA

Oby, why Ukandu your husband?

OBIAGELI

What is wrong in marrying my husband, after all . . .

CHIOMA

Husband indeed!

OBIAGELI

You'll be the happiest woman on earth with Ukandu as your husband.

CHIOMA

Say that to the wind! A man with swollen scrotrum does not complain of its heaviness, but the onlookers die of pity for him.

IFEOMA

You've started again with your rantings.

CHIOMA

I'm sure Oby is contented with her husband. We may only be seen as mere intruders. Ifeoma, as for me, I'm off. [*Makes an attempt to leave*].

OBIAGELI

Chi-Chi, is it you talking like this? Both of you surprise me. I thought I had friends on whom I can rely in times of trouble.

CHIOMA

Obiageli, our sole aim of being here is to commiserate with you and . . .

IFEOMA

[*Continuing as if reading Chioma's mind*] . . . and to share in your problems and perhaps proffer a worth-while solution as good friends should do.

OBIAGELI

I told Chioma of my misfortunes and my state of helplessness.

CHIOMA

A fly perching on the sore must be dealt with cautiously.

IFEOMA

Let us not grope in the dark. We should be able to know the root cause of this problem so as to know from which angle to tackle it.

CHIOMA

But rumour has it that he already has a son.

OBIAGELI

That is not true!

IFEOMA

I heard that his wife deserted him a long time ago.

OBIAGELI

I am not aware of the fact that he has a child. But I learnt the wife ran away with a very rich man to the big city.

IFEOMA

I heard that version too. It is said that the man was a stranger.

CHIOMA

The chicken-hearted-fool might not have performed his marital duties well. The woman must have been tired of negligence.

OBIAGELI

[*Dejectedly*]. Ukandu does not, as much as touch me, let alone cuddle me. I feel dejected, rejected and cast aside each day that crawls past. I pray everyday to God concerning this issue. But of course, that one, in his usual slow and seemingly nonchalant attitude is yet to hear my voice. He . . .

IFEOMA

[*Snaps in*]. Beware of blasphemy!

CHIOMA

Which oracle have you consulted, and to which god have you sacrificed?

IFEOMA

Rather than consult any oracle, which will tell you what you wish to hear, I have a different view. But before we go on, we have to be sure of one thing.

CHIOMA

[*Desperately*]. We are wasting time.

IFEOMA

No. We are rather being diligent in our search.

OBIAGELI

Ify, what do you want us to be sure of?

IFEOMA

Does Ukandu, love you?

CHIOMA

[*Irascibly*]. What a silly question to ask!

OBIAGELI

[*Calmly*]. Ifeoma, that is not the issue at stake now.

IFEOMA

Look, it's very relevant. You see, we may be making a mountain out of a mole hill.

CHIOMA

What do you mean?

IFEOMA

Ukandu may not be as bad as . . .

OBIAGELI

[*Interrupting*]. Look, you do not understand. Ukandu does not go after other ladies, he is not the stingy type, he gives me all that I need . . .

IFEOMA

[*Cuts in*]. But what, enh? What else do you need. [*Obiageli and Chioma exchange glances*]. Patience, patience is all you need. With time everything will be alright.

CHIOMA

A little child that admires the beauty of burning flames does not know how it feels when touched.

OBIAGELI

[*Calmly*]. Ifeoma, it is ignorance that makes you talk like this and . . .

IFEOMA

It's time, time that will . . .

OBIAGELI

Is twenty-eight whole weeks not enough time for a husband to fully exxplore the body of his wife? Look, I have hoped for too long, and empty hope makes love wane.

CHIOMA

Ifeoma, let me tell you, Oby's husband is a man outside but a cocoyam leaf inside.

IFEOMA

What do you mean?

OBIAGELI

His manhood does not know the strength of my little finger [*demonstrates with one of her fingers*] once, I tried to caress it in the night in my wild quest to feel like a married woman. But what did I get? A shock! [*Mimicking*]. "look here woman" he got up, "don't ever in your entire life try that rubbish with me". I merely slumped on the bed belly-wise regretting the day I knew this man.

IFEOMA

[*Ruefully*]. It is a tough life for a woman. I'm sorry I did not know it was a log you married.

CHIOMA

But I told you!

IFEOMA

I did not understand you before now.

OBIAGELI

So, you see, all that rubbish about his having a child is a fable.

CHIOMA

It still boils down to the same thing. The man is not a "man".

IFEOMA

What do you mean?

OBIAGELI

Ukandu has some occultic dealings!

IFEOMA

Yet you say he loves you?

CHIOMA

I don't see how that is relevant here!

IFEOMA

A loving husband confides in his wife. No secrets!

CHIOMA

[*Reflectively*]. That's cruel! Look, Oby, Ify, our elders say that it is common-sensical to search for a black goat when the sun has not yet gone to sleep.

IFEOMA

There you go again! We are talking about serious things you are talking about searching for black goat!

OBIAGELI

I understand what she means. But from where do we start the search?

IFEOMA

My question is this: Are there any traces of occultism in this house?

CHIOMA

That's a very good question.

OBIAGELI

[*Pointing to a door*]. Ever since I stepped into this house, Ukandu has never opened that door. My fears were heightened and my conjectures confirmed the day he walked up to me and said sternly [*mimicking*] "don't ever get your body near that door, let alone touch it".

CHIOMA

And you obeyed?

OBIAGELI

What would I have done?

IFEOMA

Tufiakwa! What a fool you've made of yourself! Look, the man and his wife are one. You own him not more or less than he owns you . . .

CHIOMA

[*Cuts in*]. Nothing can be too personal to a husband for his wife not to have an idea about. You merely allowed this castrated bull-dog to use you.

OBIAGELI

[*Nodding in agreement*]. I really did.

CHIOMA

But today, if you permit us, we'll break the jinx.

OBIAGELI AND IFEOMA

[*In unison*]. Yes, yes break the jinx, we must.

[*As if following a dramatic cue, they dash towards the door, force it open and rush inside; and there comes a loud shout by the trio from within, amidst which there is a sharp blackout*].

SITUATION 8

And suddenly, as the shout continues, lights transfer to down stage left where Ukandu is revealed with other men of his age playing draught and drinking in a bar. Then, suddenly, Ukandu begins to behave funny while playing the draught. A voice or two urge [s] him "Ukandu play on".

UKANDU
[*As he stares into empty space, the shouts continue shrilly*]. Yes! Catch them! Waste them! Ehm! A-haha! Hihi-ho-ho-ho!

A MAN
Ukandu, what's wrong with you?

SECOND MAN
If you've lost the game, give in to your superior and stop . . . [*Ukandu springs up and upturns the board and remains transfixed, gazing into space*].

VARIOUS PLAYERS
Ukandu! A-ha Ukandu!! He is acting.

HIS DRAUGHT CHALLENGER

[*Moving towards him*]. Ukandu are you alright? [*As he stands transfixed, and looking into emptiness, Uwakwe's voice is heard over the microphone*].

UWAKWE'S VOICE

. . . lastly and most importantly, no living soul should ever have access into the room where the Mmuoego's spirits imhabit! ha! ha! ha! ha!ha!

UKANDU

[*As the shrill laughter in his mind's ears subsides, he turns slowly to face them*]. Go away. Leave my house, a-a-a-h-ee—all of you! Out! [*Picks up a bamboo chair on which they were sitting, throws it aiming at nobody in particular. Menacingly, he moves towards them as they retreat. "It is suggested that, all the movements and mime in this situation be rhythmically choreographed". As he advances, they retreat and lights dim gradually to a blackout*].

MOVEMENT TWO

SITUATION 1

Same as the prologue. Ulooma, now in her early fifties, looking vibrant and sophisticated, is seen moving about preparing lunch. A car horn is heard. A lad aged about twenty-eight comes in with a suitcase in his right hand; and a suit hung loosely on his left shoulder. He wears a moody look that distorts his handsome face.

ULOOMA
[*Collecting the suitcase and the suit*]. You are unusually early today, I was just trying to prepare your meal when I heard the horn.

OSONDU
I am not hungry.

ULOOMA

What? How can't you be hungry? You went out in the morning without eating your breakfast. And now you say you're not hungry.

OSONDU

Mama, there is no need to make an issue out of this. I've lost my appetite. May be it would be over in the next few days.

ULOOMA

[*With awe*]. Days? What do you mean? [*Getting emotional*] you are all I have. My entire life hinges on you. The eyes and the nose both share their joys and sorrows together. Please, tell me what it is that aches you.

OSONDU

[*Dejectedly*]. Mama, I am . . . Emm . . . I . . .

ULOOMA

[*As if remembering something*]. Okay. All right, now I can see. It is the dream, isn't it? You see, you need some laxatives to flush out those "nyama-nyama" things that cause horrible nightmares.

OSONDU

[*Nonchalantly*]. Oh mama! I need some rest. [*Moves into the inner room*].

ULOOMA

[*Soliloquises*]. Poor boy! Sometimes, when I look at him I see clearly a man quite different from his useless father. He is all I have, all I live for ; in fact, without him, life makes no meaning to me. I hope he doesn't have any cause to think of knowing who the father is or where his village is. But, what could that dream have meant? [*Voice over the microphone as she freezes in a reflective mood*].

VOICE

Mama, tell me, who is Umuagwu? I mean, what, or who is Umuagwu?

ULOOMA

No! he must not know. We need happiness and to maintain it, his ignorance of his root must remain. But, supposing he knows, what do I do?
BLACKOUT

SITUATION 2

A night club, the player is blasting at its highest and the jolly youngsters are shuffling and shifting their bodies to the hip-hop rhythm rending the air. Others are either drinking or smoking with their partners in the corner. Lights reveal Osondu and Obiageli at a corner in a love mood, with two bottles of soft drink in front of them. Music switches to blues preferably "Endless Love" by Lionel Richie and Diana Ross. As the music plays on lovers are seen glued to each other. Spotlight reveals Osondu and Obiageli downstage, holding close to each other and moving their bodies rhythmically.

OBIAGELI

[*As the music reduces in volume*]. Do you realise you are still a complete stranger to me?

OSONDU

[*Perplexed*]. How do you mean?

OBIAGELI

[*Matter-of-factly*]. You are yet to tell me anything about your family background. All I keep hearing is the same question "will you marry me?" I mean I don't even know you.

OSONDU

Neither do I know you. You know, my dear, these things are done gradually. There is no haste at all. The most important thing is that I need you and I shall love you for as long as I live on the surface of this earth.

OBIAGELI

Thanks. I love you and I've always longed to have an Igbo as my husband.

OSONDU

Meanwhile, which part of Igbo are you from?

OBIAGELI

Umuagwu.

OSONDU

[*Wildly excited*]. Umu . . . what? [*Disengages and moves gently towards their seat*].

OBIAGELI

[*Surprised and shocked*]. Osondu!

OSONDU

[*Inaudibly*]. So there is really a name like Umuagwu? [*Pacing*].

OBIAGELI

Osondu, what is it?

OSONDU

E-em, Oby, I think we should get out of here; you understand?

OBIAGELI

[*Getting worked-up*]. But why? Why all this feeling of uneasiness?

OSONDU

Because, I need some rest.

OBIAGELI

But, why the sudden change?

OSONDU

[*On their way out*]. Don't worry darling, we'll discuss it at a more convenient time and place.

BLACKOUT.

SITUATION 3

Morning. Osondu sits in the parlour mulling over something briefly, then breaks into a soliloquy.

OSONDU

Umuagwu! Umuagwu; why, for goodness sake does this name keep throwing me off? Mama had told me not to take the dream serious. But I think there is more to it than meets the eyes. I can't even remember the contents of the dream except that the name Umuagwu keeps reverberating in my mind's ears. The eeriness of the dream and the incomprehensible sound of the flute keep floating in my mind. Or could mama have been hiding facts from me? Has it got to do with my love- Obiageli? But mama hasn't said anything about my roots. All I hear is that papa and his only brother died in a ghastly motor accident, when I was barely four months old. I mean I don't even know who I am, where I'm from and my relatives. All that I have in life is mama, and, now Obiageli. Obiageli, Obiageli my love,

The name that means a lot to me

My love for you is great I know

Upon the mountain high above

I'll chant your name forever more.

[*Feels more depressed as a dirge floats in*].

ULOOMA

Oh my God! Osondu, what time is it that you are not getting ready to go to work?

OSONDU

A-ah, mama, why did you creep into my privacy like that?

ULOOMA

First, tell me why you are not at work.

OSONDU

Mama, relax. Just come and have your seat. We really have a lot of things to discuss.

ULOOMA

Your breakfast is ready.

OSONDU

Thank you ma. But, we have some things to iron out.

ULOOMA

[*Perplexed*]. You sound strange. I hope all is well.

OSONDU

Let's hope so mama. Em, ehn mama, there is ehm, I mean, I have someone who is . . . I mean with whom I am badly, no, ehmm . . . seriously, ehm, yes seriously in love.

ULOOMA

[*Apparently relieved that it's not as serious as she thought*]. Oh, that's only natural my son. And it is only a fool who tries to reverse the natural course of events. Meanwhile, who is she?

OSONDU

Her name is Obiageli.

ULOOMA

[*Contented*]. I see, there is no need to ask where she is from. So long as she is Igbo, I give my consent wholeheartedly. But my dear, love is not enough reason for you to stay back from work.

OSONDU

It's much more than that mama, Obiageli wants to know everything about me. I was embarrassed when she asked me where exactly in Igbo land I was from ; and why I was given such a name when I was not burn during any war.

ULOOMA

[*Impatiently*]. So what did you tell her?

OSONDU

[*Sincerely*]. Nothing. What could I have told her? I mean, do I even know who I am?

ULOOMA

Osondu, how can you say such a thing about yourself?

OSONDU

What mama?

ULOOMA

I mean, reasonable people do not talk like that.

OSONDU

Oh, [*stands*] so it is unreasonable to say the truth.

ULOOMA

What truth, enh? Kedu eziokwu obu? Osondu kedu ife ne'me gi? What is wrong with you? I have told you for the umpteenth time that your father died . . .

OSONDU

[*Interrupting*] That is not the issue now, mama. All I keep hearing is "your father died in a motor accident" and so on and so forth. This my father, did he not have a root? I mean, a hometown or a place where his only son could call a home?

ULOOMA

But Osondu why all this?

OSONDU

Because I want to know my roots.
[*Ulooma stares dumfounded at Osondu who looks sternly at her. She merely turns and moves moodily away into the adjoining bedroom. Osondu moves towards her calling out "mama". Almost immediately, the doorbell rings. He walks towards the door with mixed feeling. Obiageli looking excellently spruced up, comes into the parlour. They kiss*].

OSONDU

I hope you didn't find it difficult locating the place?

OBIAGELI

Not at all! This is a beautiful apartment, and your living room is magnificent.

OSONDU

I'm flattered. Thanks all the same. Do you mind some juice drink?

OBIAGELI

[*Smiling*]. No, I don't. Thanks.

[*Osondu moves to the refrigerator and produces a bottle of drink and a glass, pours the drink for her and goes into the inner room, and re-emerges in a matter of seconds with Ulooma*].

OSONDU

Mama, here is Obiageli [*Obiageli before the end of the speech, quickly kneels in greeting*].

OBIAGELI

Good morning ma.

ULOOMA

Good morning my daughter. Osondu has told me so much about you. In the morning, it is Obiageli, afternoon, Obiageli, night, Obiageli. Obiageli has turned into his food and drinking water. [*They all laugh heartily*]. You are welcome once again my daughter.

OBIAGELI

Thank you ma.

ULOOMA

He did not tell me you were coming. I would have prepared . . .

OBIAGELI

[*Cuts in*]. Oh do not worry mama, I'm all right.

ULOOMA

[*Teasingly*]. Merely looking at you, something within me tells me that my son has found his true wife. You are pretty!

OBIAGELI

Oh mama, I feel really flattered. Osondu, I can see you're just like your mother.

OSONDU

What else do you expect?

OBIAGELI

Like mother, like son, or is it like son, like mother! [*They all laugh heartily*].

ULOOMA

Obiageli, you have a very good sense of humour. You may have inherited it from your parents too. Meanwhile, how are your parents?

OBIAGELI

Fine ma.

ULOOMA

You are here with them in Lagos?

OBIAGELI

No, I am staying with one of my aunts here in Lagos. My parents are both in the village.

ULOOMA

Where is your village?

OBIAGELI

Umuagwu.

ULOOMA

[*Almost screaming*]. W-h-a-t?

OSONDU

Mama, what is the matter?

ULOOMA

Nothing. I was only wondering if . . . ehm . . . I could . . .
never mind.

OBIAGELI

Osondu, remember this was exactly the way you reacted
when I told you I was from Umuagwu. And when I asked
you why you reacted that way, you said we were going to
discuss it at a more convenient place and time.

ULOOMA

It is much more convenient now, my daughter. There is no
smoke without fire and there is nothing new under the sun.
The world is a funny place. It is cyclical in nature. But my
fear is that after this revelation, your dream of getting married
shall have been shattered.

OSONDU AND OBIAGELI

[*Simultaneously*]. What?

ULOOMA

Yes, because as it stands, you people cannot, and will not marry each other.

OSONDU

[*Getting emotional*]. Mama, such words are like arrows piercing through the flesh of my body to the bottom of my heart.

OBIAGELI

Mama, what is my fault? I'm ready to make amends, if you will give me a second chance. But first, I'll like to know my flaws and sins.

ULOOMA

It's not your fault! Neither is it his nor mine. Osondu is my all in all. I suffered all alone to mould him into what he is today. I can't imagine, neither can I fantasise keeping quiet and watching him walk to his death. "Tufiakwa!!" God forbid bad things!.

OSONDU

Mama, I'm yet to follow your drift.

ULOOMA

Osondu listen my son, no mother wishes to be vicious to the child to the extent of depriving him of his life long happiness. Every good mother wishes the best for her child. But in our case, my hands are tied. [*Pauses to fight back tears making her eyes to be misty*]. But there is a debt I've owed you for too long now. It's time to settle it. [*Breaks into tears and moves towards Osondu, embraces him and sobs profusely over his shoulder*]. Please son, promise me you'll forgive me.

OSONDU

I have, even before you asked.

ULOOMA

I'm so ashamed of myself. I don't even know where to begin from.

OSONDU

Mama, pull yourself together. All is well.

ULOOMA

I'm sorry son, I have been keeping you under the illusion that your father died in a motor accident. In fact, your father is alive and is from Umuagwu.

OBIAGELI

My goodness!

OSONDU

But mama, why were we ostracized from my father?

ULOOMA

He wanted to kill you for wealth when you were barely four months old. You were all I had, and I wanted you to stay alive. So, that night, I had to steal you, and steal out of the village, not wanting anybody to know of our whereabouts, and here we are.

It was not easy for you and me. I started hawking oranges and groundnuts with you strapped on my back. And when we found our feet, I swore never, never to have anything doing with the village of Umuagwu in my entire life [*resolutely*] so, you see, my daughter, your marriage with my son, simply put, is an impossibility.

OSONDU

Mama, that was a very sad and bitter experience. But Obiageli and I have sworn to live in peace. Our wedding can take place here in Lagos and none shall think of any harm on us. There are courts and churches where we can wed.

ULOOMA

No child, my son must be honourably married to his wife. Tradition demands that we meet the parents for marital negotiations. And as far as it is Obiageli you've to marry, the sands of Umuagwu expect a kiss of our feet, and that, I abhor!!!

OBIAGELI

This is a hard nut. But mama, don't you think that over the years Osondu's father may have changed his ways becoming an entirely different person?

ULOOMA

[*Sarcastically*] That is not an impossibility my daughter. After all, he changed from a husband I married to a drunkard and a killer. It is, therefore, not impossible for him to transform into a monster and a vampire.

OBIAGELI

That's not what I mean, mama.

OSONDU

Or mama, it could be a sweet re-union—a long lost son and a repentant father.

ULOOMA

Osondu, let me warn you, you are toying with your life.

OSONDU

Of what value is life for me
Without my love, without my life?
To me she's all the life I live
And life with love combined as one
Will make our earth a blissful place.
I hate to think of losing her, for none can be like her to me.
My love for her cannot be cut
Except by death and death alone.

OSONDU AND OBIAGELI

On bended knees we beg of you
Revoke your plight and bless our will
To come as one forevermore
To change the world in which we live.
[*Pathetically, Ulooma moves towards them and stretches her two
hands and as she raises them, a sharp blackout*].

MOVEMENT THREE

SITUATION 1

Lights catch up with a group of people sitting in a semicircular form. Prominent among them are Osondu, Ulooma and Obiageli. They are gorgeously dressed. The atmosphere is festive and there is a general revelry.

An old man moves out of the crowd down stage with a glass of drink [*palm wine*] in his right hand to pour libation.

<center>OLD MAN</center>

Umuagwu kwenu!

<center>CROWD</center>

Yah!

<center>OLD MAN</center>

Ndi ba'nyi kwenu!!

CROWD

Yaah!!

OLD MAN

Kwezuonu!!!

CROWD

Yaaah!!!

[*A drunk, Okolo, interrupts, as he staggers into the semi-circle*]

OKOLO

I must speak first on this occasion before all of you! Blind fools!

OLD MAN

Get this drunk out of this place!

OKOLO

Whenever the eyes refuse to see what they should see, then, it's time for the nose to begin to smell pepper; and her plea for innocence becomes inconsequential!

OLD MAN

I say bundle this bastard out of here! [*Two hefty men readily jump out and move threateningly towards Okolo, who beats a retreat towards the table, grabs a bottle of whisky, downs it, and advances menacingly with it towards the two men, while speaking on top of his voice*].

OKOLO

You undaunted fools! How dare you, out of greed and senselessness, decide to push the venom of the puff adder down the throat of this community? For goodness sake, what is abominable is abominable! What is intolerable is intolerable!! What is condemnable is condemna . . . [*As he is ranting another set of hefty men seize him from behind, and bundle him out as he struggles helplessly to finish his message screaming*] C-h-i-e-f-s, sit back and think! Think and act wisely!!

OLD MAN

Good! Thank you for your patience! At least, it was with his hands and mouth he drank! The drink as far as I know was not forced on him through his anus. The he-goat that savours his mother's urine thinks it wise to do so, in order to avoid trouble. The child that brings joy to her family

receives blessings in return. That our daughter, after all the humiliations in the hands of her former husband, still thinks it wise to marry again from her people, is a thing of joy to us. The young man, there, we learnt is one of us, and despite his long sojourn in the big city, he still speaks our language fluently. His mother is a well-known person to us, whose family is held in high repute in this land. Therefore, we invite the gods of this land, and the spirits of our forefathers to come and bless this wedlock [*pours libation*]. On the other hand, good luck shall follow all those who wish them a happy wedlock [*pours. Changes glass to his left*]. But the wicked spirits of our land shall abide with those who wish them bad luck. [*Ovations, applause and I-s-e are to be echoed intermittently at the appropriate places*]. Mazi Eze over to you.

MAZI EZE

Thank you Nnanyi. I know I am elder as well but he is older than I am. Umuagwu kwenu! Ndi ba'nyi kwenu!! Kwezuonu!!! [*Each call receives a resounding response*]. We all know why we are gathered here today. Personally, I do not know who the new prospective husband of our daughter is. So, I ask that she introduce him to some of us who do not know him. That has always been our tradition. It is not a new thing. Let some one serve her the drink and . . .

MAZI KALU

[*Interrupting*] Just before that . . . [*clears his throat*] Umuagwu kwenu! Ndiba'nyi kwenu!! Kwezuonu!!! [*Each call receives a resounding response*]. Thank you! Please do not let us be hasty in disregarding the seeming empty ranting of Okolo, the drunk. I perceive there is sense in what he was not permitted to say! I suggest that we give reason a chance and listen to . . .

MAZI EZE

[*Interrupting rudely*] Kalu, if you were not someone I respect I would have given you a piece of my mind this morning! How dare you set out to spoil a day like this for the people of Umuagwu?

MAZI KALU

You must hear me out! [*General grumbling and noise from the Townspeople*]

MAZI EZE

[*Shouting above everyone else*] I say shut up and sit down! Who do you think you are? You are the least of all the Ndi'Ichie gathered here for this purpose, yet you have the audacity to dictate for us!

MAZI KALU

[*Sharply*] I am not dictating Mazi Eze! I am just trying to point out the truth which you are too blind to see!

MAZI EZE

[*Moving towards him menacingly*] And what truth if I may ask?

MAZI KALU

[*Emphatically*] Ah! Umuagwu, the mouth that has lost a tooth must chew with caution! Ah! Umuagwu, the journey you have just set out is doomed right from the outset! The fly that perches on the scrotum, our elders advise, must be killed with caution! Look, I tell you, there is danger ahead and we must . . .

OLD MAN

[*Irascibly*] Mazi Kalu you must be out of your senses! So you think all of us here are fools! How dare you open your filthy mouth to cast aspersions on the integrity of the chiefs in council of Umuagwu? By the customary power and authority conferred on me by the Igwe of this land, I order you to leave this arena!

MAZI KALU

He who farts while under the surface of the water can never stop the bubbles from coming up. My people, the truth can never be suppressed! It's not you that I pity, but the lives of those innocent ones placed, as it were, on a time bomb!

OSONDU AND OBIAGELI

[*In unison*] Chiefs and elders of our land,

Here we are, two of a kind! Heart to heart melted into one

With the fire of love that cannot be quenched

But kindled the more by the gods of the land!

Eyes of our land, don't allow your misunderstandings

Thwart the essence of love predestined by our gods

Play your roles as the elders of our land

And allow the gods to do their will

For as mortal men, ours is to dance the dance of destiny

As dictated by the tunes of the gods of our land!

Our love, we say can never be broken!

MAZI KALU

[*Pathetically*] My children! You don't understand! There is a pit dug in front of you! This wedlock, if carried out portends doom and . . .

OLD MAN

[*Cutting in sharply*] Mazi Kalu, in the name of whichever Evil spirit that has taken possession of you, I order you ,for the last time, to carry your ill-luck and foul mouth away from this arena, before I pronounce a curse upon you, your household, and your entire generation!!

MAZI KALU

I will leave! But before I do, a word of wisdom for you and your cohorts! Kindly tell the truth and save a generation unborn from an impending doom!![*He walks out head bowed as he moves rhythmically to a dirge provided by the orchestra*]

OLD MAN

[*Pacified at the exit of Mazi Kalu*] Please Mazi Eze, carry on with the rituals! [*There is a general ovation as Mazi Eze steps forwards and the arena becomes livelier once more*]

MAZI EZE

Thank you Nnanyi. Umuagwu kwenu! Ndi ba'nyi kwenu!! Kwezuonu!!![*Each call receives a resounding response as usual*]. The fellow that cannot withstand the heat of the scorching sun on his back, as well as the chill of the cold on his skin will have nothing but an empty barn to boast of. For these two to relish the dividends of their wedlock, this kind of confusion

is not expected! Therefore, I want to thank you all for your patience!

As I was saying before being rudely interrupted by enemies of progress, personally, I do not know who the new prospective husband of our daughter is. So, I ask that she introduce him to us who do not know him. That has always been our tradition. It is not a new thing. Let someone serve the drink and . . .

[*Amidst cheers and ululation, a man pours the drink into a glass and offers it to Obiageli who receives it and moves among curious men towards Osondu. She drinks and gives it to Osondu, who drinks in return. Applause. Ukandu looking contemptibly haggard and half nude comes in with his double-barreled gun. As the people see him, everybody takes to his heels except Osondu, Ulooma and Obiageli, who are too stunned to believe their eyes. In a split moment, he aims at Obiageli, but before Osondu can recover from the shock to shout "no", he fires a shot and drops her down, and turns almost immediately at Ulooma, and drops her down too. He turns and begins to walk out. Osondu makes to follow him but changes his mind as Ulooma calls out "Osondu help me". He rushes to her and kneels besides her propping her head up*].

ULOOMA
[*Gasping*]. My son, that man is your father. This is . . . indeed the prize of your stubbornness. [*Drops dead*]

OSONDU
[*Shouting*]. No.o.o, m-o-t-h-e-r!
[*Obiageli groans. He drops his mother's head and hurries to Obiageli*].

OSONDU
Obiageli my love. Tell me you are alive and all will be well. [*Kisses her*]. I still love you . . .

OBIAGELI
[*Gasping*]. That man . . . your father, my husband, killed me . . . it's all over. This is a . . . lost . . . lust. [*Drops dead*].

OSONDU
[*Screaming*]. No.o.o! [*Moves dizzily to his mother's corpse*]. No . . . it's not true! Someone wake me and say it's all a nightmare.

Oh no, but it's real, there she lies . . . my love . . . there she lies my mother. [*Cries*]. Life is so cruel! Mother, is this how I pay you back for all your sufferings and care for me?

Obiageli, is this how we'll change the world, with you lying still there? No! No! No! Drive them ! Kill them!! [*To nobody in particular*] Ukandu, I'm going to kill you! Kill you!! Kill you!!! [*Slaps himself, seems to enjoy it, does it again and again. Begins to strip himself naked.*

VOICES

Beware of Ukandu

Beware of Umuagwu

Cut the tree, leave the root

The tree will surely spring to life.

[*He freezes in a reflective mood as he hears the voices. Ukandu enters*].

OSONDU

You killed your wives and my mother and my wife and your wives and my mother and my wife. [*They move towards each other slowly. "It should be noted that the following speech is not an anti-climax, so caution should be taken to arouse the emotion of the audience*].

UKANDU

That is the spirit my son. The world itself is mad. So,[*voice over through the microphone*].

VOICES

To stay alive, we all are mad. Yes, I, am mad, you are mad, we are all mad!! Mad for love, mad for wealth, mad for life, and for all the things of life.

[*Ukandu and Osondu should be at mid-stage facing each other as the voice over comes to an end*].

BLACKOUT

ABOUT THE AUTHOR

Christian C. Ekwunife holds his M.A. and B.A. degrees in theatre arts from the University of Ibadan, Nigeria. He has researched variously on theatre criticism and contemporary theatre practice. His academic papers have been published in Professional Academic Journals. He is a playwright and a theatre critic. The indelible scar of a lost lust is his second published play.